ESSENTIAL GUIDE TO
DRAWING
Landscapes

DRAWING

Landscapes

A PRACTICAL AND INSPIRATIONAL WORKBOOK

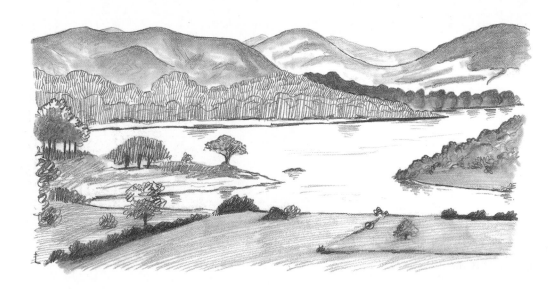

BARRINGTON BARBER

ARCTURUS

ARCTURUS

This edition published in 2019 by Arcturus Publishing Limited
26/27 Bickels Yard, 151–153 Bermondsey Street,
London SE1 3HA

ISBN: 978-1-78888-897-4
AD002353UK

Printed in China

CONTENTS

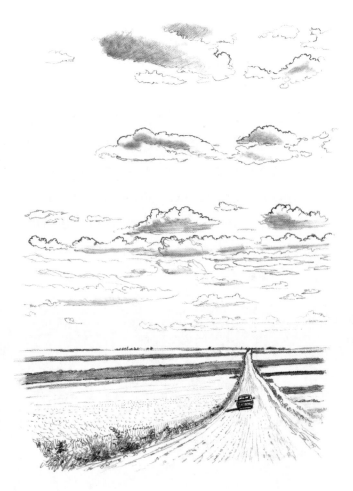

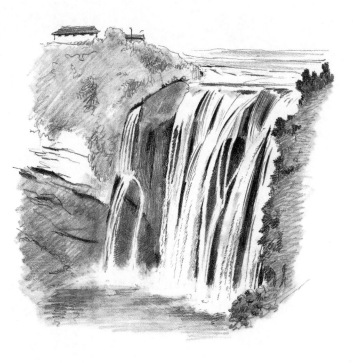

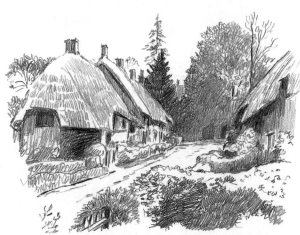

Introduction

When we study something in order to make a picture of it we chiefly use our eyes.
However, surveying a landscape involves all our senses. Out in the open, we are
suddenly aware of the prevailing weather and the sounds and smells around us.
From the narrow focus of a still-life group or reclining figure, we switch to the view
of distant horizons, big skies and stretches of water. Landscape drawing does not
mean representing everything as precisely as a camera might, any more than the
Impressionists did with their paints. The power of the marks that you make with your
pencil, pen or brush lies with their ability to tap into our most fleeting memories and
our boundless imaginations.

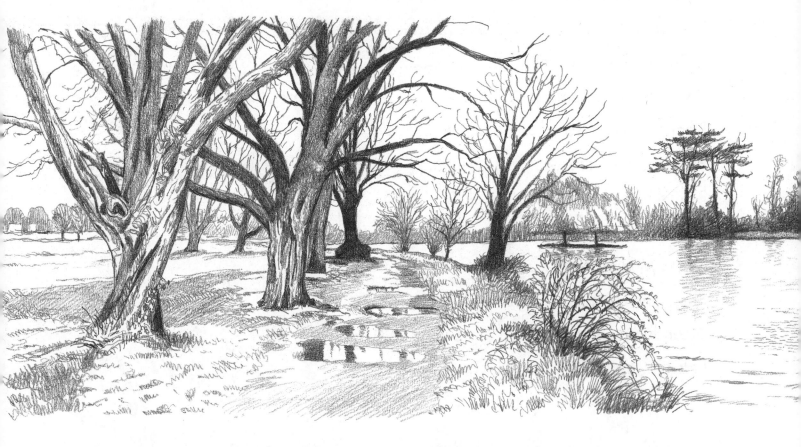

Landscape is an enormous and variable subject
and any preparation for it will never be wasted
time. What you'll soon notice is that it is all
about textures, from the reflective surface of still
water to rough grasses and rugged stony ground.

You'll also begin to realize that what you draw
on a small scale can be replicated on a larger one,
which will give you confidence: if you can draw
a foreground rock convincingly, you can draw a
mountain too.

Any medium is valid for drawing landscapes and I have shown a range of possibilities here and later in the book. You probably don't need to buy all the items listed below, and it is wise to experiment gradually. Start with the range of pencils suggested, and when you feel you would like to try something different, do so. For paper, I suggest starting with a medium-weight cartridge paper.

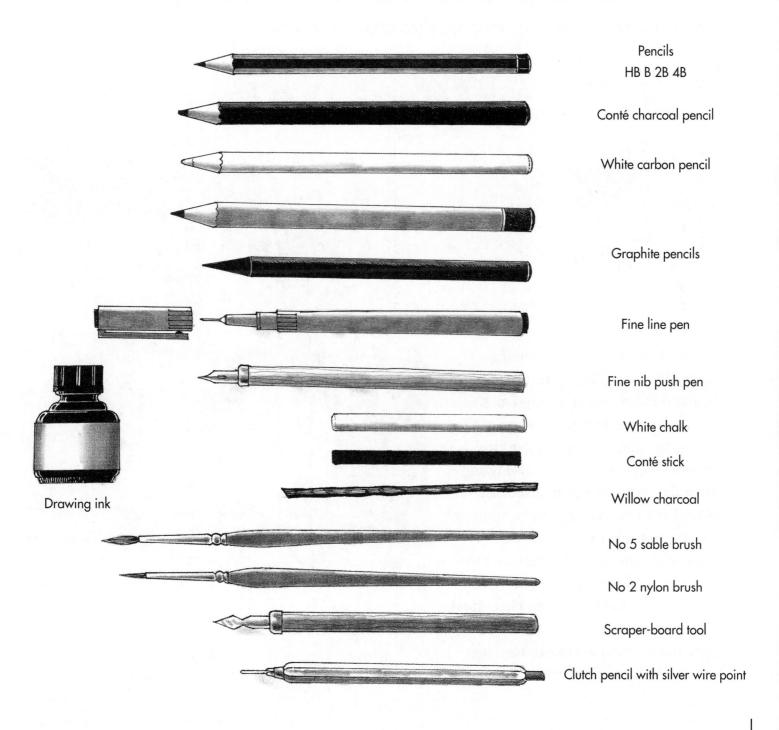

Pencils
HB B 2B 4B

Conté charcoal pencil

White carbon pencil

Graphite pencils

Fine line pen

Fine nib push pen

White chalk

Conté stick

Willow charcoal

Drawing ink

No 5 sable brush

No 2 nylon brush

Scraper-board tool

Clutch pencil with silver wire point

The World Around Us

To begin to draw landscapes, you need a view. Look out of your windows. Whether you live in the countryside or in the town, you will find plenty to interest you. Next go into your garden and look around you. Finally step beyond your personal territory, perhaps into your street. Once we appreciate that almost any view can make an attractive landscape, we look at what lies before us with fresh eyes. The three views shown here are of the area around my home.

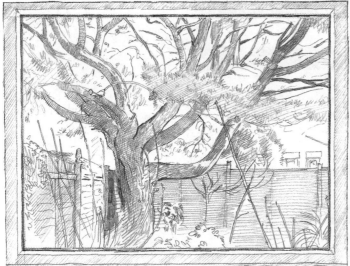

When I look out of the window into my garden, I see a large pine tree of the Mediterranean type. It is a graceful tree and obscures most of the rooftops of the houses backing on to the garden. The window frame usefully restricts my angle of vision so that I have an oblique view of the left-hand fencing with its climbing ivy. Across the back of the garden is a fence with some small bushes under the tree. Plants grow right under the window and their stalks cut across my view. Apart from a few details of the house behind ours, this landscape is mostly of a large tree and a fence, and a few smaller plants.

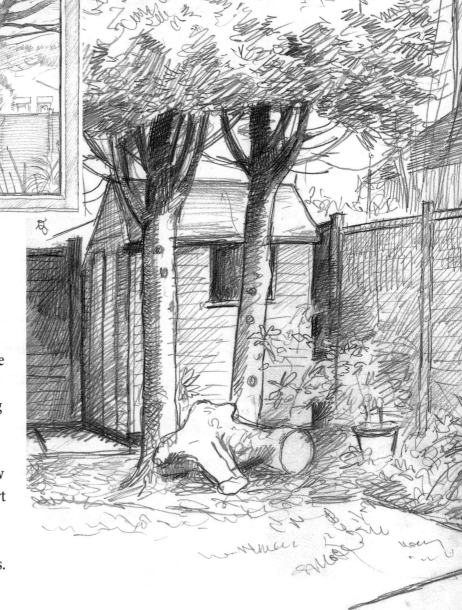

In this outside view of the garden we are looking away from the pine. Behind the fence can be seen the roof of a neighbour's house and some trees growing up in the next-door garden. In the corner of my own garden there is a small shed with two small fir trees growing in front of it with a large log at their foot. The flowerbed to the right is full of plants, including a large potted shrub, with ivy growing over the fence. Closer in is the edge of the decking with flowerpots and a bundle of cane supports leaning against the fence. A small corner of the lawn is also visible. The main features in this view are a fence, two trees and a garden hut.

The third drawing (below) is of the view from my front gate. Because all the houses in my road have front gardens and there is a substantial area of trees, shrubs and grass before you reach the road proper, the scene looks more like country than suburb. We see overhanging trees on one side and walls, fences and small trees and shrubs on the other, creating the effect of a tunnel of vegetation. The general effect of the dwindling perspective of the path and bushes either side of the road gives depth to the drawing. The sun has come out, throwing sharp shadows across the path interspersed with bright sunlit splashes. The overall effect is of a deep perspective landscape in a limited terrain.

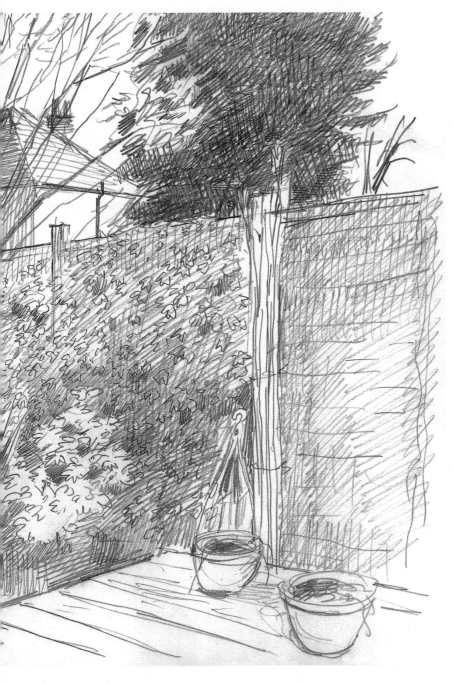

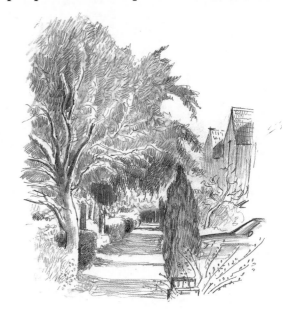

///// Framing a View

One way to get a better idea of what you are going to draw when
you attempt a landscape is to use a frame. Artists often cut out
part of the view by blocking off the edges with their hands. The
drawing on page 8 was isolated in this way by the ready-made
frame of the window. Most artists use a frame at some time as a
means of limiting the borders of their vision and helping them to decide
upon a view, especially with large landscapes.

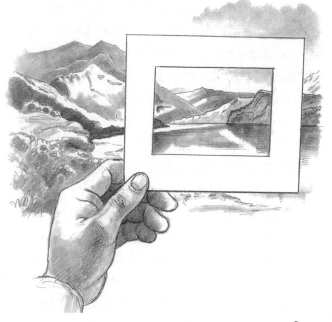

In the example to the left, a lakeland view has been
reduced to a simple scene by isolating one part of it.
With landscape drawing it is important to start with a
view you feel you can manage. You will see how the key
shapes are made more obvious by the framing method.

By cutting out a rectangle of card not much larger
than 5 cm x 4 cm (2 in by 1–1½ in) and holding it up
against your chosen landscape, you can begin to control
exactly what you are going to draw. Move it closer to
your eyes and you see more, move it further away and
you see less of a panorama. In this way you can isolate
the areas that you think will make a good composition
and gradually refine your choice of image.

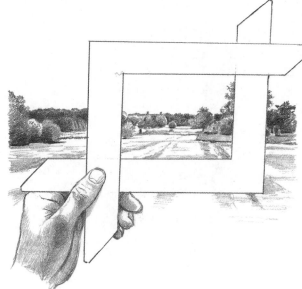

This more sophisticated frame, consisting of two right-
angled pieces of card, enables you to vary the proportion
of your aperture and allows greater scope for variation.

At some point you will have to decide how large your picture is going to be. Starting small and gradually increasing the size of your picture is advisable for the inexperienced. Ideally, you should have a range of sketchbooks to choose from: small (A5), for carrying around, medium (A4) and large (A3), for more detailed drawings. The cover of your sketchbook should be quite stiff to allow it to be held in one hand without bending while you draw.

Drawing a landscape on an A5 pad is fairly straightforward, but it does limit the detail you can show.

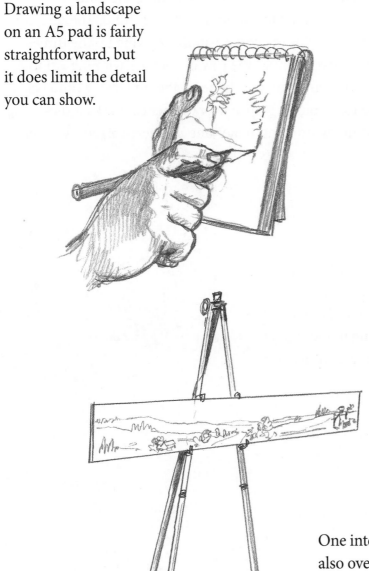

When you are more confident, try a larger landscape on an A2 size sheet of paper. This can be placed on a board mounted on an easel or just leant against a convenient surface.

One interesting landscape shape is the panorama (see also overleaf), where there is not much height but an extensive breadth of view. This format is good for distant views seen from a high vantage point.

///// Landscape Formats

Put simply, there are four possible types of landscape to be considered in terms of the size and shape of the picture you are going to tackle. Your landscape could be large and open, small and compact, tall and narrow or very wide with not much height.

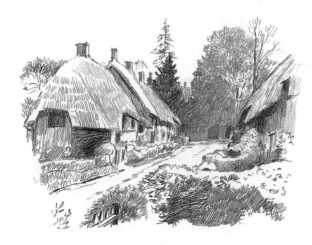

Small and compact

The emphasis here is on the details and textures in the foreground, with a structural element in the middle ground and a well defined but simplified background. The direction of the light helps the composition, showing up the three-dimensional effects of the row of cottages with the empty road between them and the solid-looking hedges and walls in the foreground. Notice how the pencil marks indicate the different textures and materiality of these various features.

Open and spreading

The most impressive aspect of this example is the sculptural, highly structured view of the landscape. This has been achieved by keeping the drawing very simple. Note that the textures are fairly homogenous and lacking in individual detail. The result is a landscape drawing that satisfies our need for a feeling of size and scope.

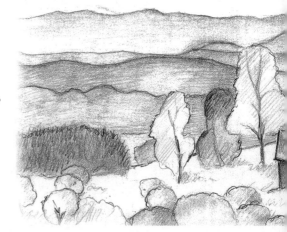

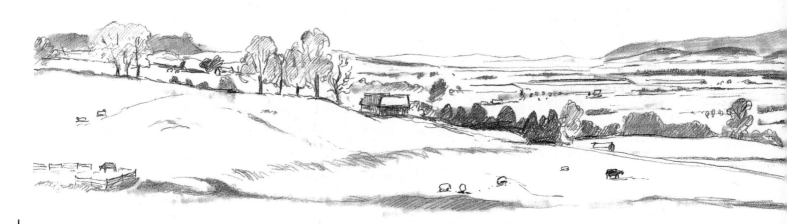

Tall

Because most landscapes are horizontally extended, generally speaking, the vertical format is not appropriate. However, where you are presented with more height than horizontal extension the vertical format may come into its own, as here. The features are shown in layers: a road winding up a hill where a few cypresses stand along the edge of the slope, sharply defined; behind it another hill slants off in the opposite direction; and above that the sky with sun showing through mist.

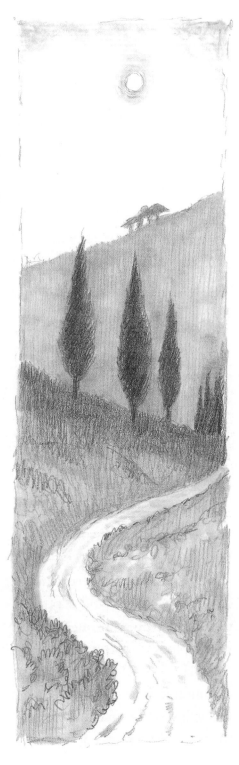

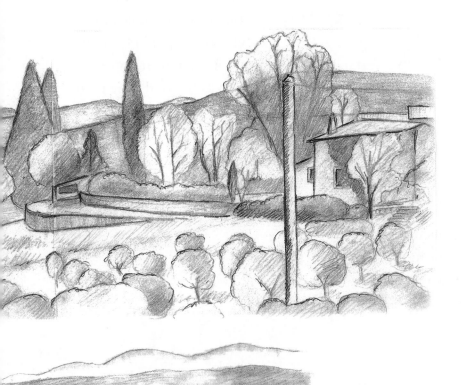

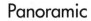

Panoramic

The basis of landscape is the view you get when you rotate your head around 90 degrees and cover a very wide angle of vision. However, this type is not easy to draw because you have to keep changing your point of view and adjusting your drawing as you go.

Types of Perspective

Because the eye is a sphere it comprehends the lines of the horizon and all verticals as curves. You have to allow for this when you draw by not making your perspective too wide, otherwise a certain amount of distortion occurs. Below we look at three types of perspective, starting with the simplest.

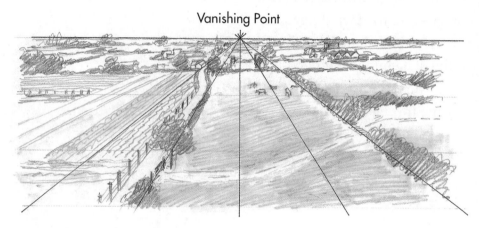
Vanishing Point

One-point perspective

The most simple and obvious type of perspective is one-point perspective, where all the lines of the landscape will appear to diminish to a single point right in front of your view on the far horizon, known as the vanishing point.

Two-point perspective

Where there is sufficient height and solidity in near objects (such as houses) to need two vanishing points at the far ends of the horizon line, two-point perspective comes into play. Using two-point perspective you can calculate the three-dimensional effect of structures to give your picture convincing solidity and depth. Mostly the vanishing points will be too far out on your horizon line to enable you to plot the converging lines precisely with a ruler. However, if you practise drawing blocks of buildings using two vanishing points you will soon be able to estimate the converging lines correctly.

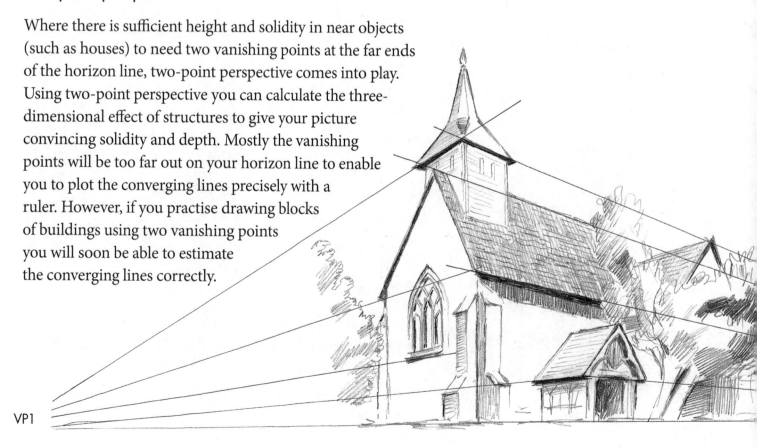
VP1

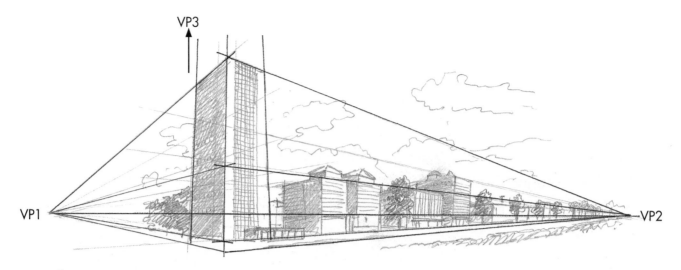

Three-point perspective

When you come to draw buildings that have both extensive width and height, you have to employ three-point perspective. The two vanishing points on the horizon are joined by a third fixed above the higher buildings to help create the illusion of tall architecture. You have to gauge the point of the convergence in the sky; often, artists exaggerate this in order to make the height of the building appear even more dramatic.

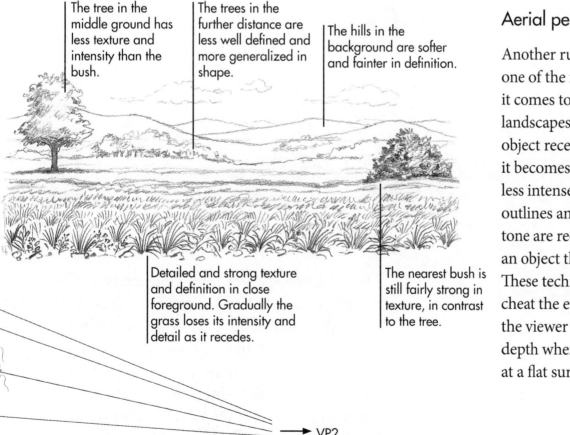

The tree in the middle ground has less texture and intensity than the bush.

The trees in the further distance are less well defined and more generalized in shape.

The hills in the background are softer and fainter in definition.

Detailed and strong texture and definition in close foreground. Gradually the grass loses its intensity and detail as it recedes.

The nearest bush is still fairly strong in texture, in contrast to the tree.

Aerial perspective

Another rule of perspective – one of the most useful when it comes to drawing rural landscapes – is that as an object recedes from the viewer, it becomes less defined and less intense. Thus both softer outlines and lighter texture and tone are required when we draw an object that is a long way off. These techniques also help to cheat the eye into convincing the viewer he is looking into a depth when he is in fact gazing at a flat surface.

Finding a landscape to draw can be very time-consuming. Some days I have spent more time searching than drawing. Never regard search time as wasted. If you always just draw the first scene you come to, you may miss some stunning opportunities. Reconnaissance is always worthwhile. Let's look at some different kinds of viewpoint and the opportunities they offer the artist.

A view along a diminishing perspective, such as a road, river, hedge or avenue, or even along a ditch, almost always allows an effective result. The change of size gives depth and makes such landscapes very attractive.

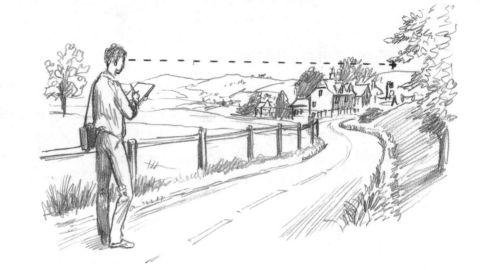

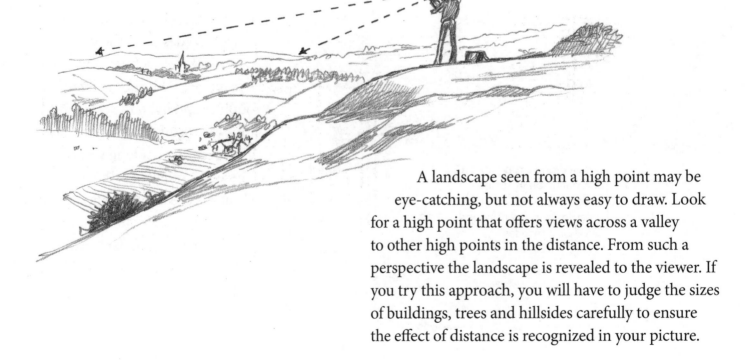

A landscape seen from a high point may be eye-catching, but not always easy to draw. Look for a high point that offers views across a valley to other high points in the distance. From such a perspective the landscape is revealed to the viewer. If you try this approach, you will have to judge the sizes of buildings, trees and hillsides carefully to ensure the effect of distance is recognized in your picture.

Editing your viewpoint

You don't have to rigorously draw everything that is in the scene in front of you. Sometimes you will want to include everything, but often some part of your chosen view will jar with the picture you are trying to create. If you cannot shift your viewpoint to eliminate what doesn't look quite right to you, just leave it out. The next two drawings show a scene before and after 'editing'.

In this view, a telegraph pole and its criss-crossing wires, a large tree and a car parked by the road complicate what could be an attractive landscape.

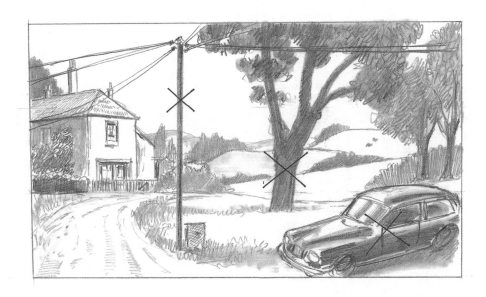

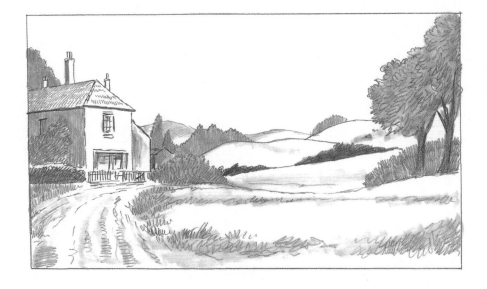

Eliminate those objects and you are left with a good sweep of landscape held nicely between the country cottage and the unmade road, and the coppice of trees over to the right.

Now I want you to tackle a landscape drawing that can be done close to where you live. Pick a nice day when you won't have to be struggling with the wind or trying to protect your drawing from the rain – the idea is to make things as easy as possible for yourself on your first attempt to draw a real landscape.

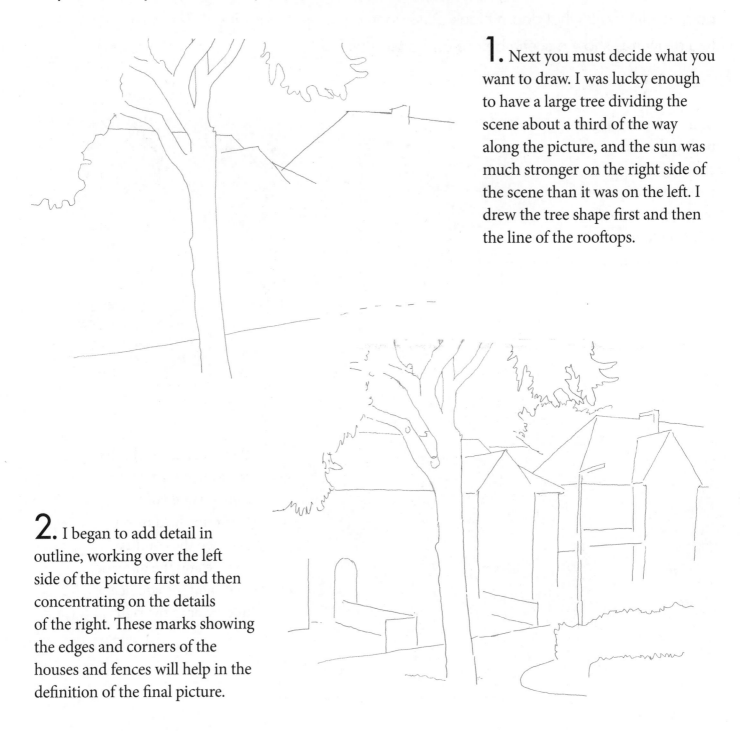

1. Next you must decide what you want to draw. I was lucky enough to have a large tree dividing the scene about a third of the way along the picture, and the sun was much stronger on the right side of the scene than it was on the left. I drew the tree shape first and then the line of the rooftops.

2. I began to add detail in outline, working over the left side of the picture first and then concentrating on the details of the right. These marks showing the edges and corners of the houses and fences will help in the definition of the final picture.

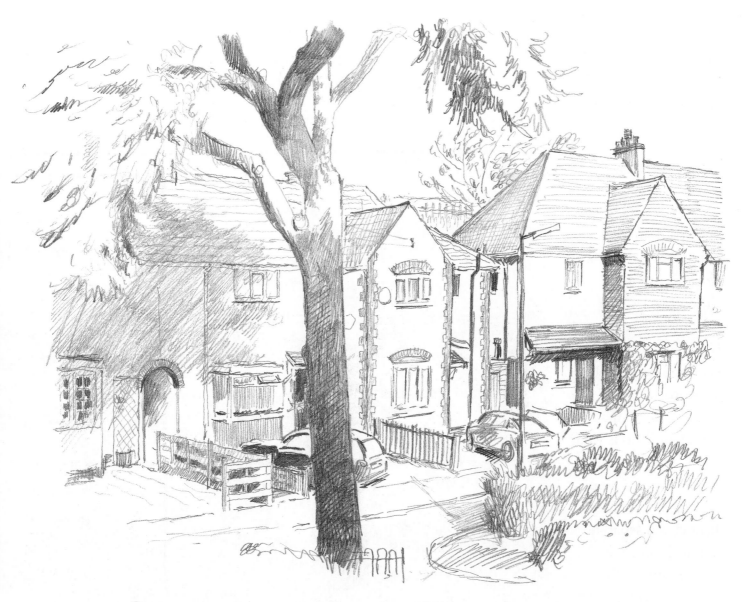

3. When you come to describe the solidity of the buildings and the tree trunk, you can use your shading techniques to explain the textural qualities as well. For example, the roof tiles will look more convincing if your tone is put on with horizontal strokes, with a slight undulation to them to suggest the ridges of the tiles. The vegetation, as in the hedge in front, can be shaded with scribbly marks to suggest the myriad leaf-tips. Try to make the marks on the tree trunk a bit broken to suggest the roughness of the bark. Each area of shading can reinforce the quality of the elements in the picture in this way.

Dividing a Panorama

Here we look at how you might tackle a far more ambitious landscape. A large panorama can be very daunting to the inexperienced artist who is looking at it with a view to making a composition. There can appear to be a bewildering amount to think about.

The first point to remember is that you don't have to draw all you see. Using a viewfinder (see page 10), you can decide to select one part of the landscape and concentrate on that area alone. This is what I have done with the drawing shown here, dividing it into three distinct and separate compositions. See the next spread for assessments of the individual drawings.

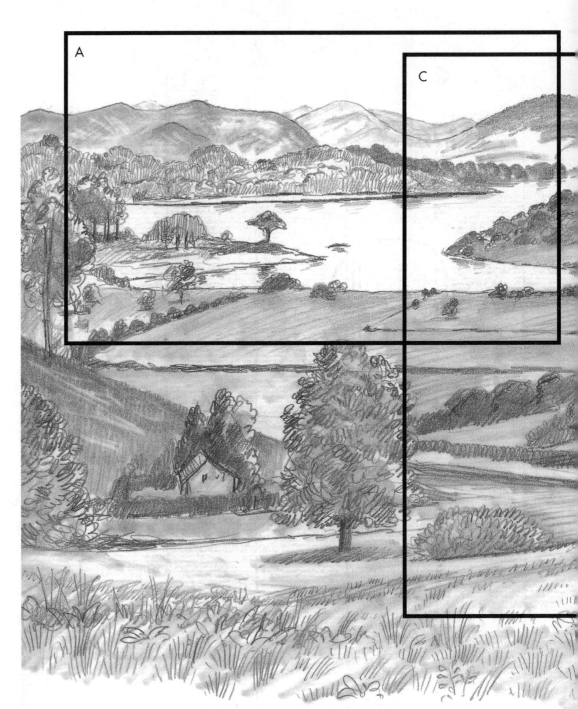

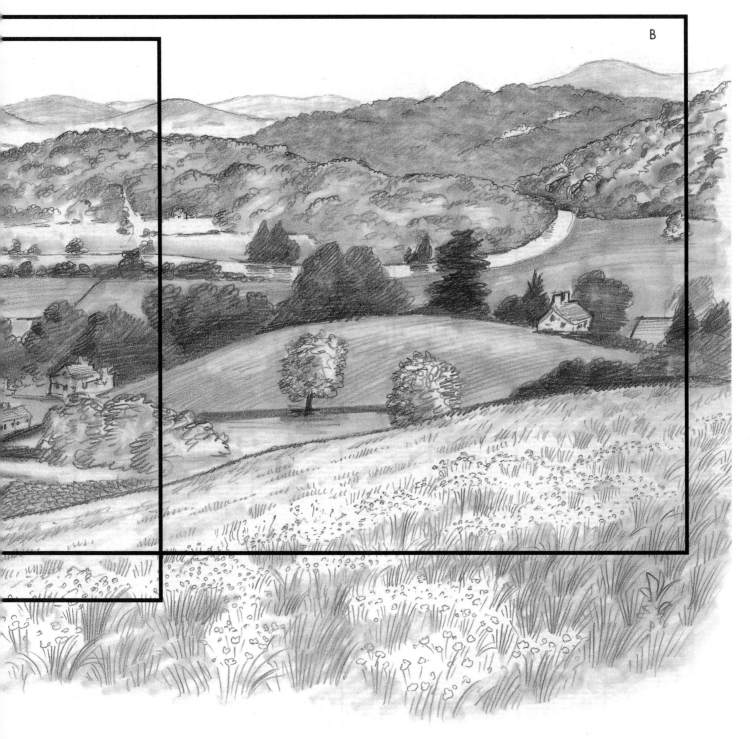

Choosing a View

I have extracted three views from the large landscape on the previous spread, each of them equally valid. Read the captions to find out how they work compositionally.

A

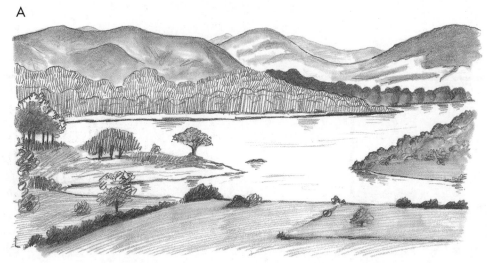

A. The main feature in this part of the landscape is a large area of water that extends across the whole composition. The large hills in the background provide a backdrop to the open landscape on the near side of the water. Two small spits of land jut out from either side just above the foreground area of open fields with a few hedges and trees.

B

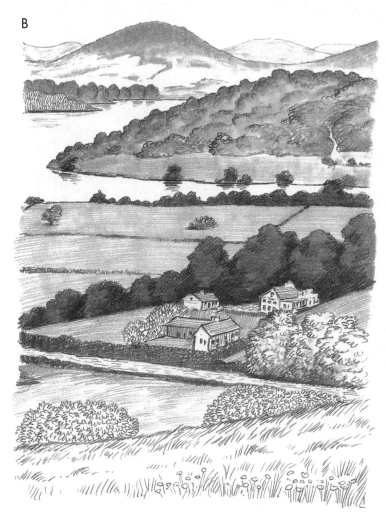

B. With its more vertical format this composition gives just a hint of the open water beyond the stretch of river in the middle ground. The extensive foreground contains hedges, trees, bushes and cottages. The wooded hill across the river provides contrast and the slope of hillside in the near foreground also adds dimension. The distant hills provide a good backdrop.

C

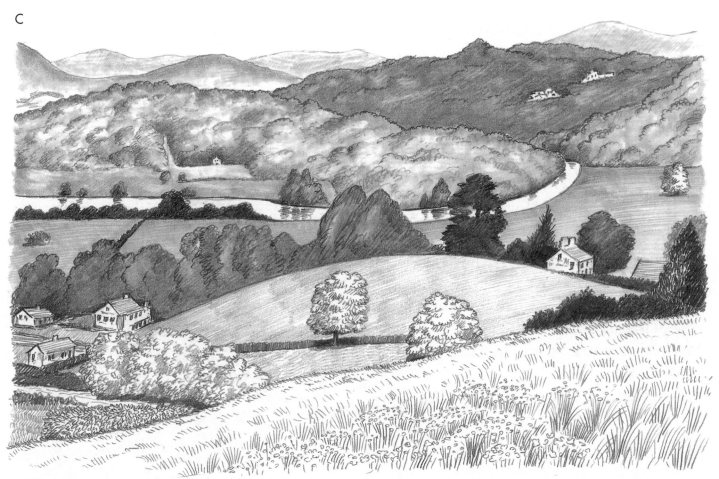

C. Here we have a horizontal layered set of features receding back into the picture plane. In the foreground is a close-up of a hillside sloping across from right to left. Just beyond is a low rounded hill-form surrounded by trees and in the left lower corner some houses. Beyond the low hill is the river curving around a large bend and disappearing into wooded banks on the right. The banks slope up either side into wooded hills, and beyond these into another layer showing a larger darkly wooded hill with a couple of villages or properties to the right. At upper left is layer upon layer of hills disappearing into the distance.

Having looked at the ways in which the structure and format of a landscape can be approached, we now take the closer view, focusing on the major elements that make up the natural world and how they can be drawn to build up convincing scenery.

Earth

When drawing the solid rocks that make up the surface of the world, it can be instructive to think small and build up. Pick up a handful of soil or gravel and take it home with you for close scrutiny, then try to draw it in some detail. You will find that those tiny pieces of irregular material are essentially rocks in miniature.

If we attempt to draw a rocky outcrop or the rocks by the sea or along the shore of a river, it is really no different from drawing small pieces of gravel, only with an enormous change of scale. It is as though those pieces of gravel have been super-enlarged and you will find a similarly random mixture of shapes, sizes and forms.

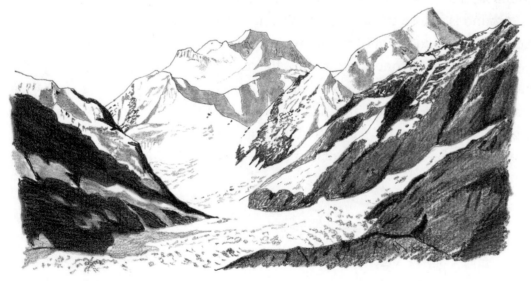

One more step is to visit a mountainous area and look at the earth in its grandest, most monumental form. This example has the added quality of being above the snowline, showing marvellously simplified icy structures against contrasting dark rocks.

Now look at a large cliff-face, with its cleavages and striations of geological layering, some of it, no doubt, partially hidden by plants, but nevertheless showing the structure very clearly.

Water

The character and mood of water changes depending on how it is affected by movement and light. Here we look at water in various forms, which present very different problems for artists and very different effects on viewers. To understand how you can capture these effects requires first-hand study, supported by photographic evidence and persistent looking and recording.

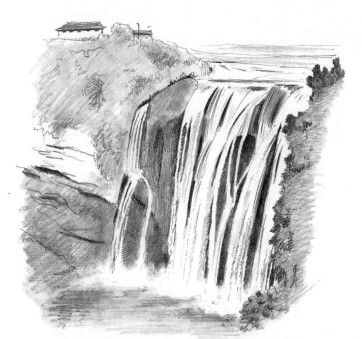

A waterfall is an immensely powerful form of water. Most of us don't see such grand works of nature as this magnificent example. Of course, you would need to study one as large as this from a distance to make some sense of it. This drawing is successful largely because the watery area is not overworked, but has been left almost blank within the enclosing rocks, trees and other vegetation. The dark tones of the vegetation throw forward the negative shapes of the water.

Unless you were looking at a photograph, it would be almost impossible to draw with any detail the effect of an enormous wave breaking towards you.

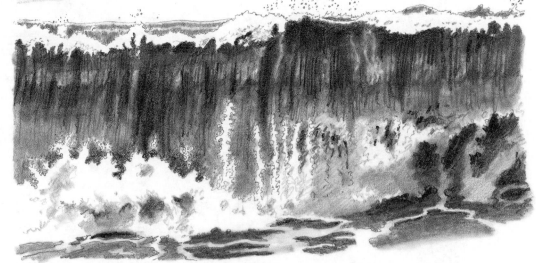

Leonardo da Vinci made some very good attempts at describing the movement of waves in drawings, but they were more diagrammatic in form.

This is water as most of us who live in an urban environment see it, still and reflective. Its surface may look smooth, but usually there is a breeze, or currents causing small, shallow ripples. Seen from an oblique angle these give a slightly broken effect along the edges of any objects reflected in the water. When you draw such a scene you need to gently blur or break the edges of each large reflected tone to simulate the rippling effect of the water.

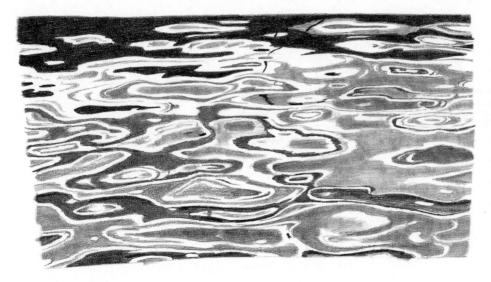

In this very detailed drawing of a stretch of water rippling gently, there appear to be three different tones for the smooth elliptical shapes breaking the surface. This is not an easy exercise but it will teach you something about what you actually see when looking at the surface of water.

The Sky: Using Space

The spaces between clouds as well as the shapes of clouds themselves can alter the overall sense we get of the subject matter in a landscape. The element of air gives us so many possibilities, we can find many different ways of suggesting space and open views. Compare these examples.

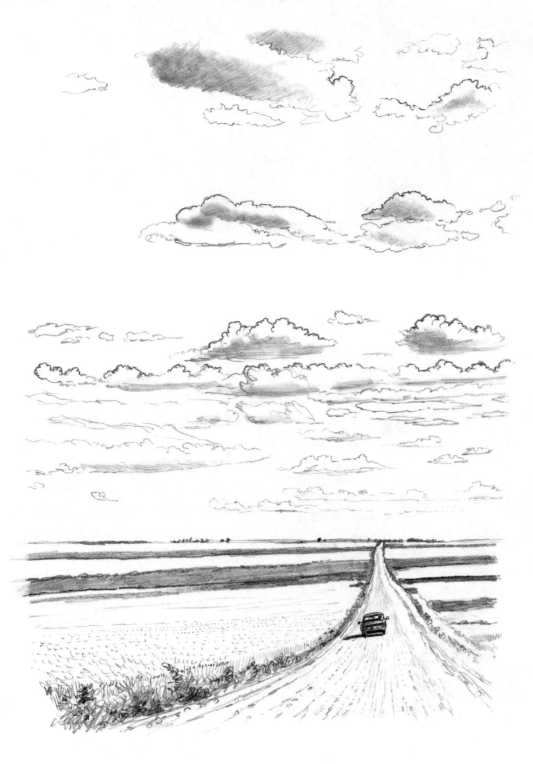

This open flat landscape with pleasant soft-looking clouds gives some indication of how space in a landscape can be inferred. The fluffy cumulus clouds floating gently across the sky gather together before receding into the vast horizon of the prairie. The sharp, single-point perspective of the long, straight road and the car in the middle distance show us how to read the space of the great outdoors.

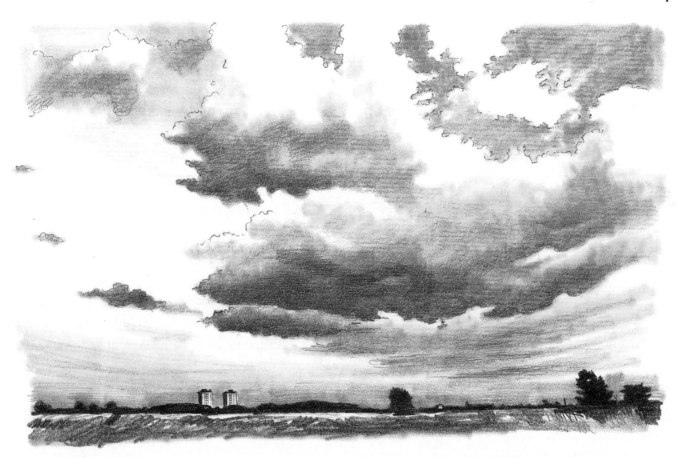

Another vision of air and space is illustrated here: a sky of ragged grey and white clouds, and the sun catching distant buildings on the horizon of the flat, suburban heathland below. Note particularly the low horizon, clouds with dark, heavy bottoms and lighter areas higher in the sky.

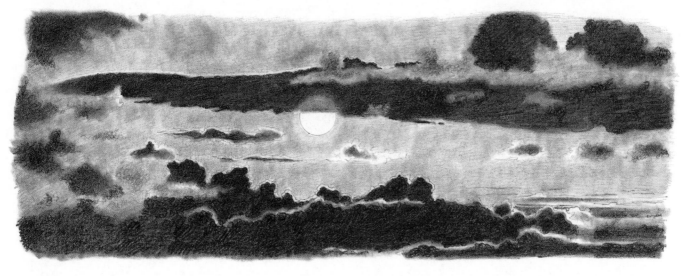

Despite the presence of dark, dramatic clouds in this scene at sunset the atmosphere is not overtly gloomy or brooding. The bright sun, half-hidden by the long flat cloud, radiates its light across the edges of the clouds, which shows us that they are lying between us and the sun. The deep space between the dark layers of cloud gives a slightly melancholic edge to the peacefulness.

Grass and Trees

Grass and trees are two of the most fundamental elements in landscape. As with the other subjects, there are many variations in type and in how they might be used as features.

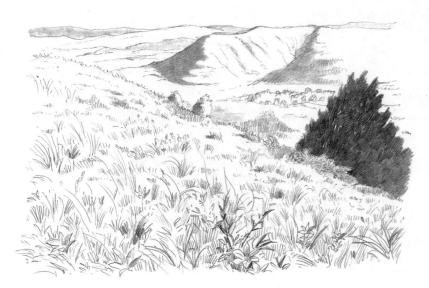

Tufts and hummocks of grass mingle with flowers in this close-up of a hillside. The foreground detail helps to add interest to the otherwise fairly uniform texture. The smoothness of the distant hills suggests that they too are grassy. The dark area of trees just beyond the edge of the nearest hill contrasts with the empty background.

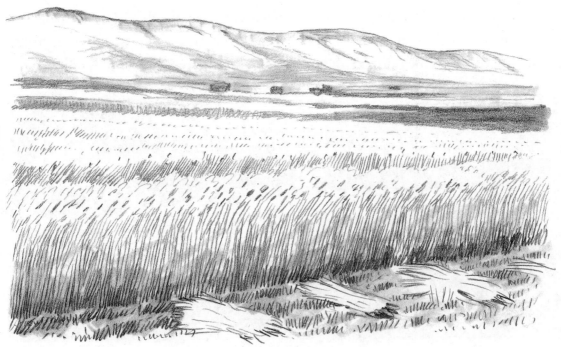

Cultivated crops produce a much smoother top surface as they recede into the distance than do wild grasses. The most important task for an artist drawing this kind of scene is to define the height of the crop – here it is wheat – by showing the point where the ears of corn weigh down the tall stalks. The texture can be simplified and generalized after a couple of rows.

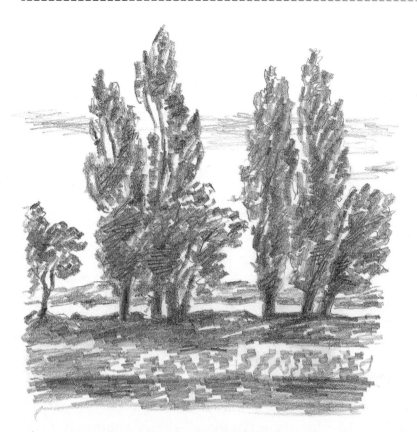

When you tackle trees, don't try to draw every leaf. Use broad pencil strokes to define areas of leaf rather than the individual sprigs. Concentrate on getting the main shape of the tree correct and the way the leaves clump together in dark masses. In this copy of a Constable the trees are standing almost in silhouette against a bright sky with dark shadowy ground beneath them.

The trees in this old orchard were heavy with foliage when I drew them, on a brilliant, sunny day. Broad, soft shapes suggesting the bulk of the trees presented themselves as textured patches of dark and light, with a few branches and their trunks outlined against this backdrop.

An area of shadow under the nearest trees helps define their position on the ground. To the left beehives show up against the shadow. In the immediate foreground the texture of leafy plants helps to give a sense of space in front of the trees.

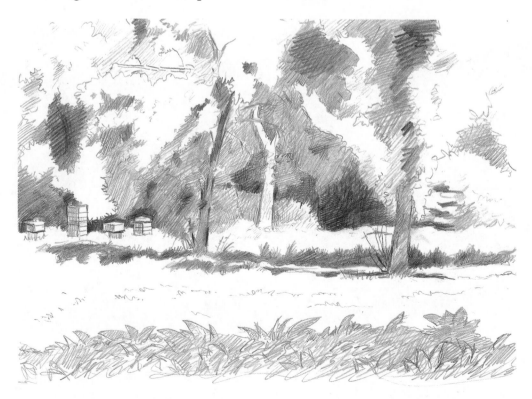

Beaches

Beaches and coastline are a rather specialized example of landscape because of the sense of space that you find when the sea takes up half of your picture.

Our first view is of Chesil Bank in Dorset, which is seen from a low cliff-top looking across the bay. Our second is of a beach seen from a higher viewpoint, from one end, and receding in perspective until a small headland of cliffs, just across the background.

In this view, a great bank of sand and pebbles sweeps around and across the near foreground, with a lagoon in front and right and hilly pastureland behind the beach at left. Across the horizon are the cliffs of the far side of the bay and beyond, the open sea. Notice the smooth tones sweeping horizontally across the picture to indicate the calm sea and the worn-down headland, and the contrast of dark tones bordered with light where the edge of sand or shingle shows white.

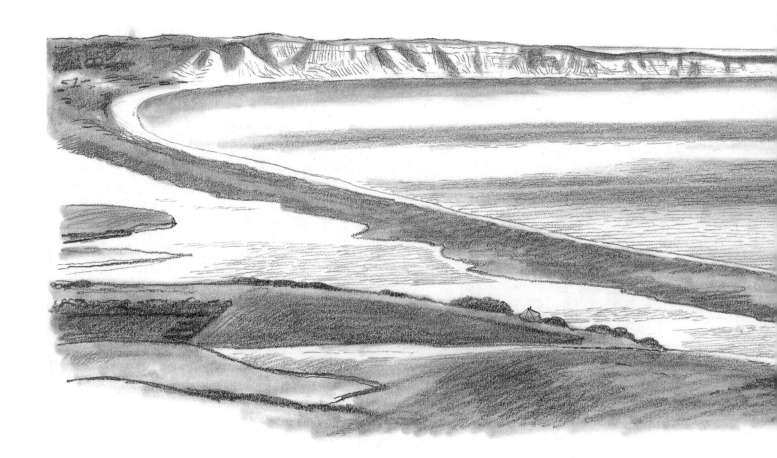

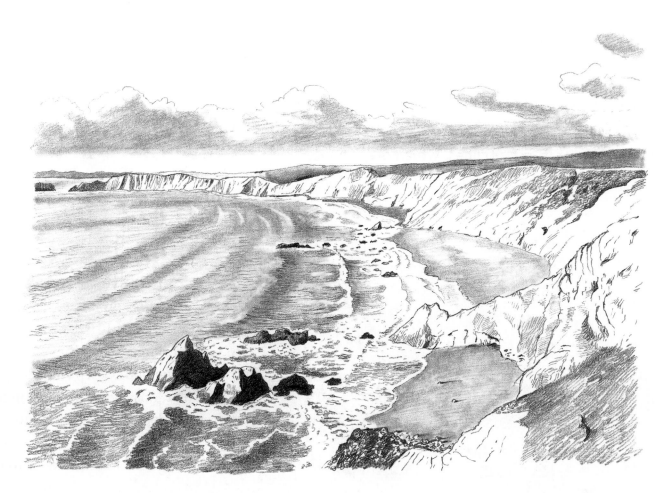

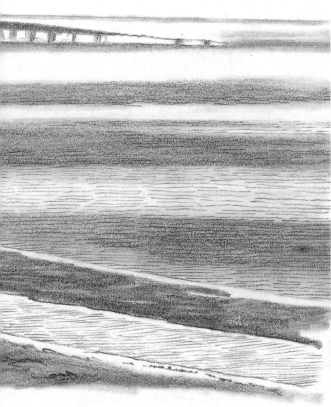

Here the dark, grassy tops of the cliffs contrast with the lighter rocky texture of the sides as they sweep down to the beach. The beach itself is a tone darker than the cliff but without the texture. The hardest part is where the waves break on the shore. You must leave enough white space to indicate surf, but at the same time intersperse this with enough contrasting areas of dark tone to show the waves. The tone of the rocks in the surf can be drawn very dark to stand out and make the surf look whiter. The nearest cliff-face should have more texture and be more clearly drawn than that further away.

▨▨▨▨ Pencil Techniques

The pencil is, of course, easily the most used instrument for drawing. Often though our early learning of using a pencil can blunt our perception of its possibilities, which are infinite.

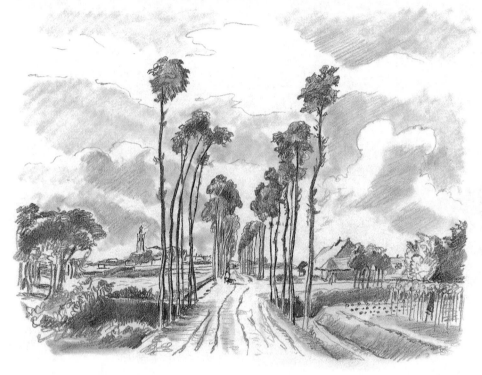

In this drawing of *Road to Middelharnis* (after Hobbema) we see a fairly free pencil interpretation of the original, using both pencil and stump. The loose scribble marks used to produce the effects in this drawing will seem simple compared to our next example.

American artist Ben Shahn was a great exponent of drawing from observation. He advocated using gravel or coarse sand from which to work if you wanted to include a rocky or stony place in your drawing, but were unable to draw such a detail from life. He was convinced that by carefully copying and enlarging the minute particles, the artist could get the required effect.

When you tackle a detailed subject, your approach has to be painstaking and unhurried. If you rush your work, your drawing will suffer. In this drawing, after putting in the detail, I used a stump to smudge the tones and to reproduce the small area of sea.

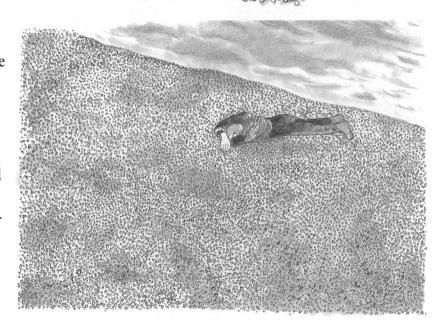

Generally speaking, any fine-pointed nib with a flexible quality to allow variation in the line thickness is suitable for producing landscapes in ink.

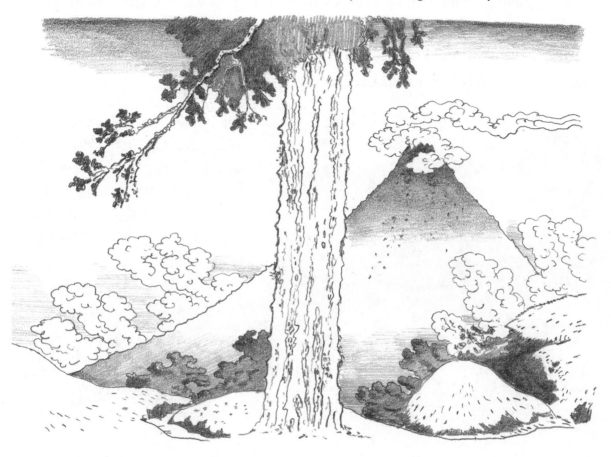

For his original of Mount Fuji the Japanese artist Hokusai probably made his marks with a bamboo calligraphic nib in black ink. We have made do with pen and ink, but even so have managed to convey the very strong decorative effect of the original. Note how the outline of the trunk of the tree and the shape of the mountain are drawn with carefully enumerated lumps and curves. Notice too the variation in the thickness of the line. The highly formalized shapes produce a very harmonious picture, with one shape carefully balanced against another. Nothing is left to chance, with even the clouds conforming to the artist's desire for harmonization. With this approach the tonal textures are usually done in wash and brush, although pencil can suffice, as here.

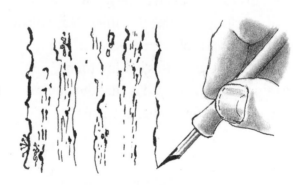

///// Chalk

Chalk-based media, which include conté and hard pastel, are particularly appropriate for putting in lines quite strongly and smudging them to achieve larger tonal effects, as you will see from the examples shown, after Cézanne (below) and Vlaminck (below right). In both cases the heavy lines try to accommodate the nature of the features and details they are describing.

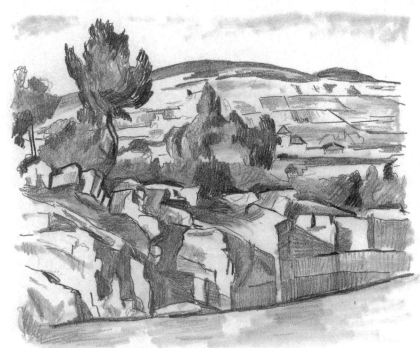

The similarity of style over the whole rocky landscape in this drawing (after Cézanne) helps to harmonize the picture. Compare the crystalline rock structures and the trees. Both are done in the same way, combining short, chunky lines with areas of tone.

Here the lines are more rounded, the areas of tone softer and the total effect seems to have been achieved with a mass of swirling, strong, solid lines. No stylistic distinction is observed between the trees and the houses behind them. The impression conveyed is that the natural world is as substantial as man's.

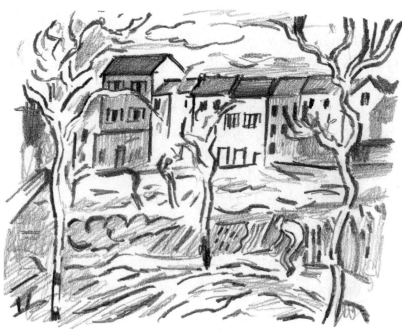

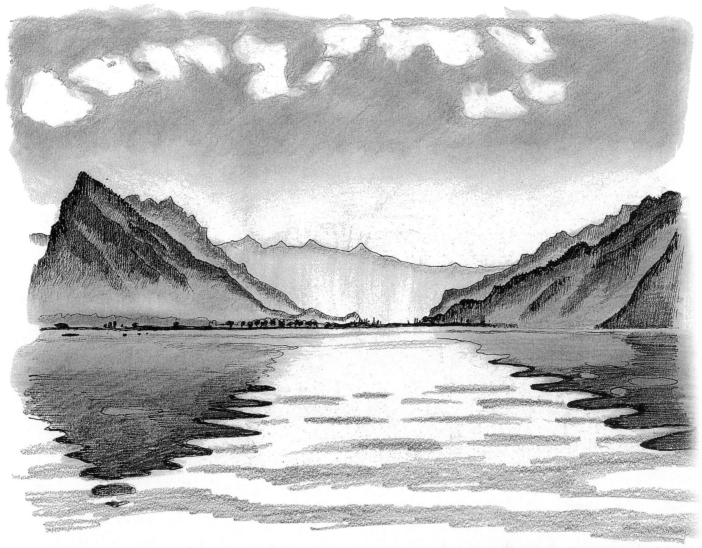

Now try out a landscape using mixed media: pen and ink and pencil or charcoal as well. This example shows large hills close to water and reflecting in it, with a cloudy sky above. Use the pencil or charcoal softly to smudge in the clouds (you can smudge the marks with a paper napkin to give a very soft effect) and then draw with the pen the outlines of the mountains and the strongest reflections of them. Fill in some of the darker areas with ink but don't overdo it. Then with the pencil or charcoal, tone in the large dark areas and smudge again to get softer effects. You will have to make stronger pencil marks close to the pen lines or else they will not blend in with the main shape. Finally, the lighter part of the reflecting water can again be smudged in with pencil or charcoal.

Use a normal graphic pen of about 0.1 or Fine Point, or if you want the drawing to stand by itself and not just as a basis for another finer drawing, use a 0.3 or 0.5 or Medium Point.

//// Sea in the Landscape: Brush and Wash

One of the most effective, and fun, ways of capturing tonal values is to do them in brush and wash. In this view of the Venetian lagoon in early morning, looking across from the Giudecca to the island of San Giorgio, its Palladian church etched out against the rising sun, the use of wash makes the task of producing a successful result much simpler.

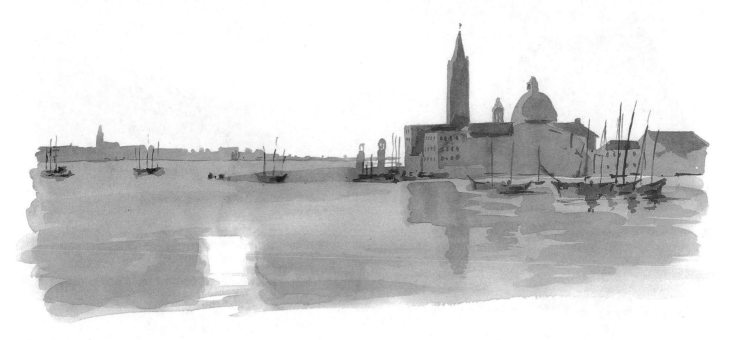

Getting the areas of tone in the right places is the key to success. It doesn't matter if your final picture is a bit at variance with reality. Just make sure the tones work within the picture. Confidence is needed for this kind of drawing and it is advisable to practise your brush techniques before you begin to make sure the wash goes on smoothly. Begin by sketching out very lightly the outline shape of the background horizon and the buildings. If you are feeling very confident, use the brush for this first stage.

First the main shape of the island and its church was brushed in with a medium tone of wash. Then while it dried the far distant silhouette of the main part of Venice was brushed in with the same tone. Then the darker patches of tone on the main area were put in, keeping it all very simple. Now it was possible to wash in a fairly light all-over tone for the water, leaving one patch of white paper where the reflected sun caught the eye. Even darker marks could now be put in with a small brush to define the roofs, the windows and the boats surrounding the island. The reflections in the water are put in next. After that, when all is dry, add the very darkest marks such as the details of the boats, to make them look closest to the viewer.

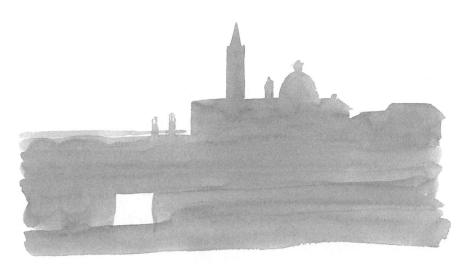

1. The first tone to put in is the lightest and most widespread which shows us the horizon line and the basic area of the buildings. Leave a patch of white paper to indicate the lightest reflection in the water. Don't worry if your patch doesn't quite match the area that you can see.

2. Your second layer of tone should be slightly heavier and darker than the first. This requires more drawing ability, because you have to effectively show up the dimension of the buildings. Also with this tone you can begin to show how the reflections in the water repeat in a less precise way the shapes of the buildings. Again, try to see where the reflections of light in the water fall.

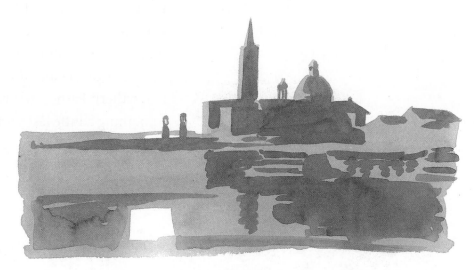

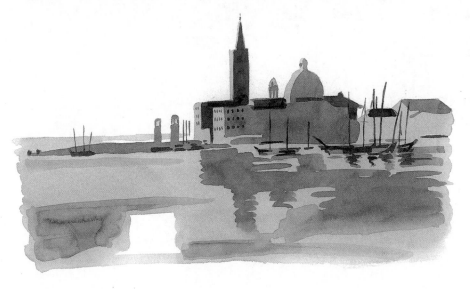

3. The third layer of tone is darker still. With this you can begin to sharply define the foreground areas. The parts of the buildings strongly silhouetted against the sky are particularly important. Now put in the patches showing the boats moored near the quay and the dark, thin lines of their masts against the sky and buildings.

A Landscape Project

Choose a location

As we have seen, the first step towards drawing a landscape is deciding on a location. Sometimes this is easy, because you happen to be in a place of great natural beauty and you have your sketchbook – the decision is made for you. However, often the reverse is true; you feel like drawing a landscape but don't have a particular one in mind. So how do you go about setting up a scene?

For this exercise, my first intention was to see how I could work up various sketches that I had done in France and Italy into a more considered composition. I began by drawing up a view of Claude Monet's famous garden at Giverny, in northern France, but finally decided that I wanted something a little less tamed.

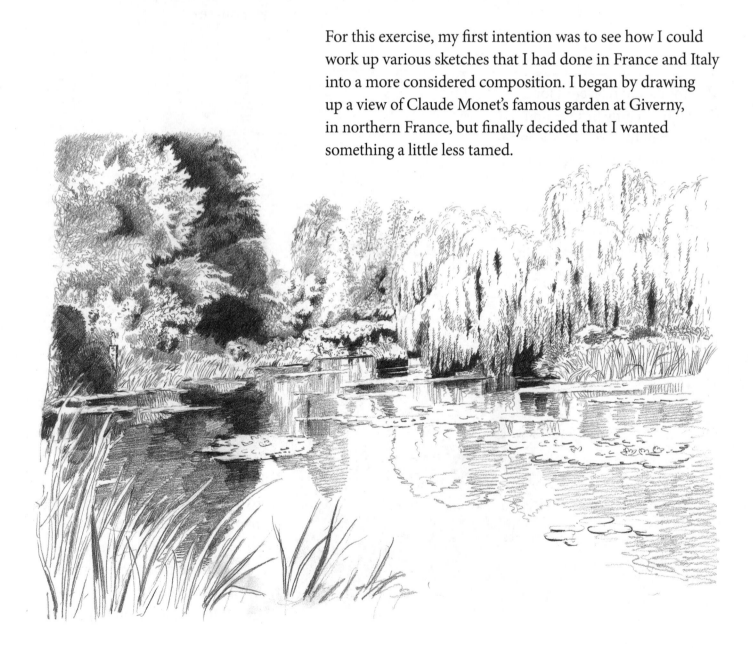

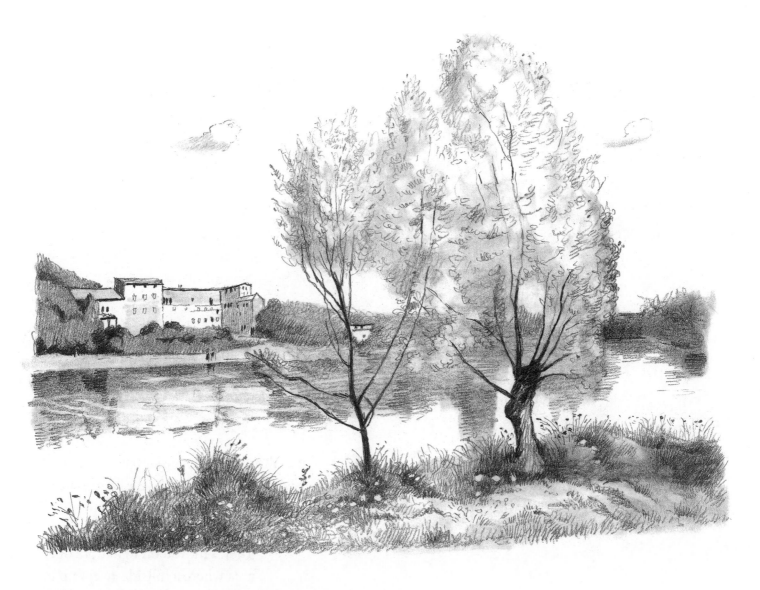

So then I looked at some sketches from Italy and worked up a view across a river, with trees in the foreground. However, I eventually felt that I wanted to start afresh with a landscape to draw from real life, so I put away my previous sketches and went out to beautiful Richmond Park, near my home.

This area is of great interest to me because of the variety in its landscape, with lakes, streams, hills and, most notably, magnificent trees. Although it's not wild countryside, it does have a breadth and range that lends itself to exploitation by the landscape artist.

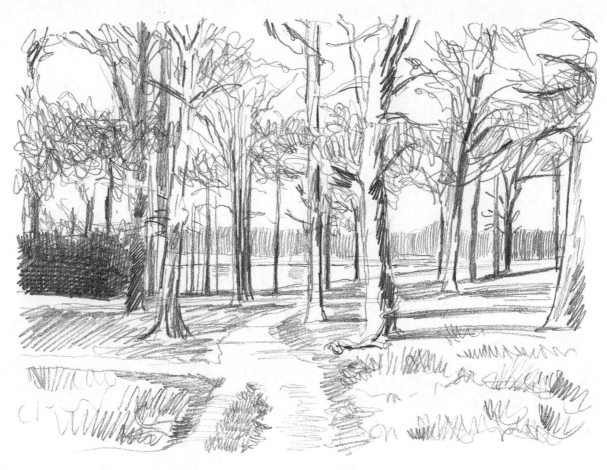

Sketching on location

I went on a long walk with my sketchbook, stopping every now and then to draw what I saw in front of me. The first pause was to draw this view of one of the lakes seen through some large trees. As it was winter there wasn't much foliage, but the bare branches of the taller trees were attractive things to draw.

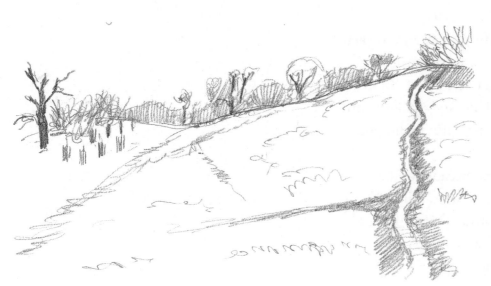

Then I moved on to a more open area where a hillside swept up to some woods in the distance. I quickly made a sketch of this and then noticed a large tree that had fallen and was gently rotting away.

I made a drawing of this from one side and then moved nearer and around to the other side to make a more detailed drawing – a great thing to use in the foreground of any landscape.

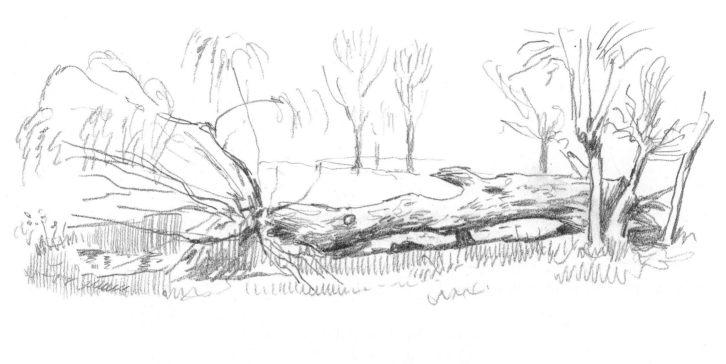

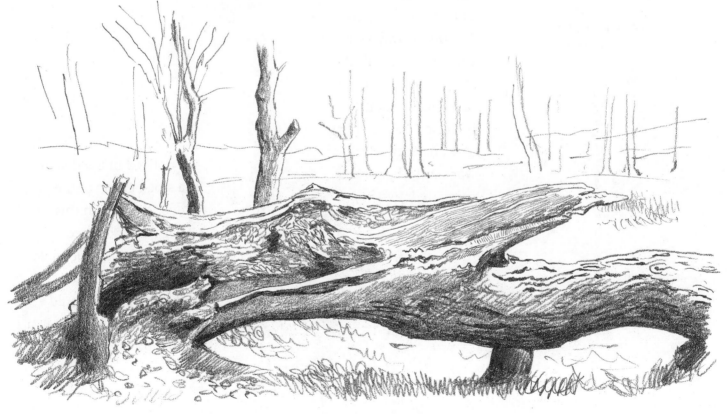

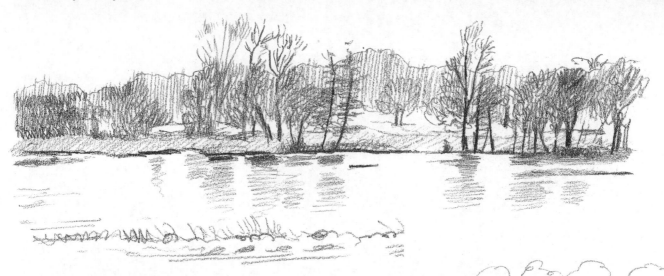

I then drew another glimpse of the lake from a distance, without any trees in front of it. This might come in handy for a background feature. So as you can see, I was beginning to compose a possible landscape picture already, without finalizing my decision yet.

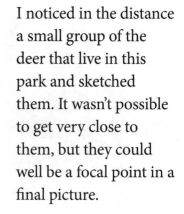

I then moved down the hill towards a stream, drawing an attractive tree on the way and then part of a reflection in the stream. I didn't take this very far, because I was realizing that I had now decided what and where I was going to draw.

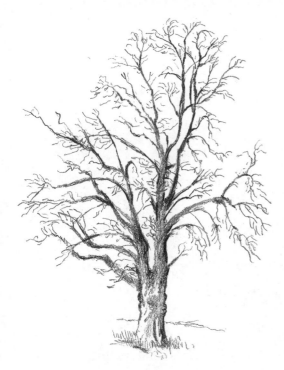

I noticed in the distance a small group of the deer that live in this park and sketched them. It wasn't possible to get very close to them, but they could well be a focal point in a final picture.

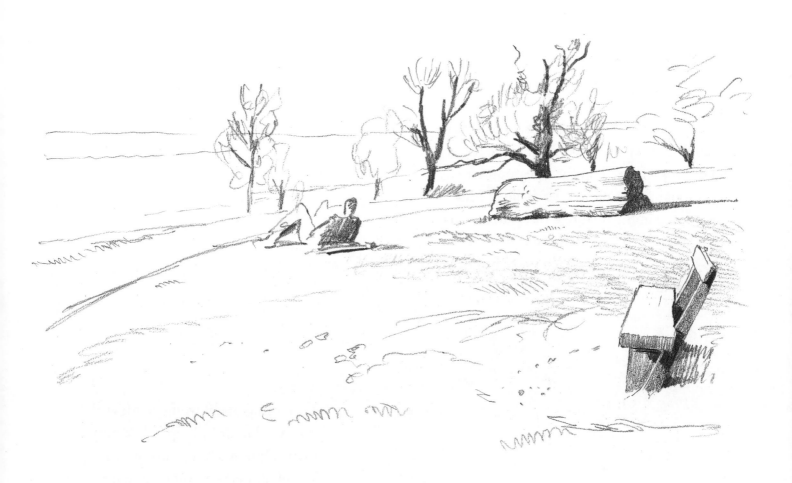

On top of a hill I drew another
log, a man resting on the ground,
and a wooden bench. Nearby
was a marvellous old dead tree
trunk, split and twisted, making
a sculptural shape, that might be
a feature for a foreground.

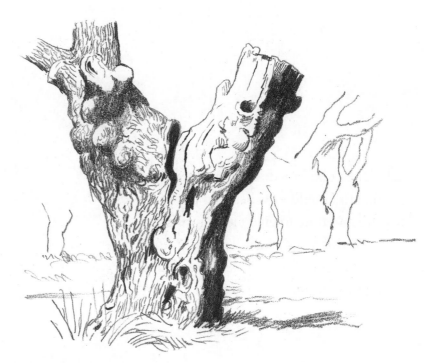

Final Composition

1. My proposed landscape was to be a view up a hillside, with the large dying tree trunk lying across the path in the foreground. I also thought a couple of deer could appear somewhere in the picture – that is to say, my landscape would be a composite of several views. I made a rough sketch to see how it might look.

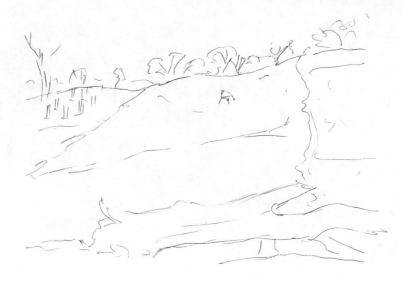

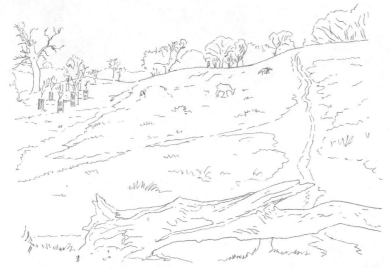

2. Feeling that it would work well, I proceeded to draw it up in line only, at which point I could sort out any difficulties of composition and drawing.

3. Once I had made all the corrections I needed to I could now begin to put in the texture and tone to give the picture more body. At this stage I kept the tone even and at its lightest, just in case I needed to change anything.

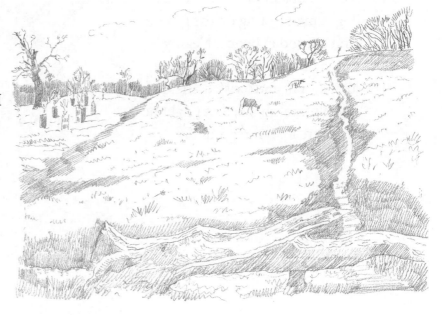

4. Then came the final push to build up the depth and feeling of space that I wanted to see in the drawing. The deer almost disappear on the hillside, but they do work as a muted focal point in the composition. The path going up the hill helps to draw the eye into the picture and the undulating horizon of the hillside draws the eye around the picture to the dead tree standing on the left.

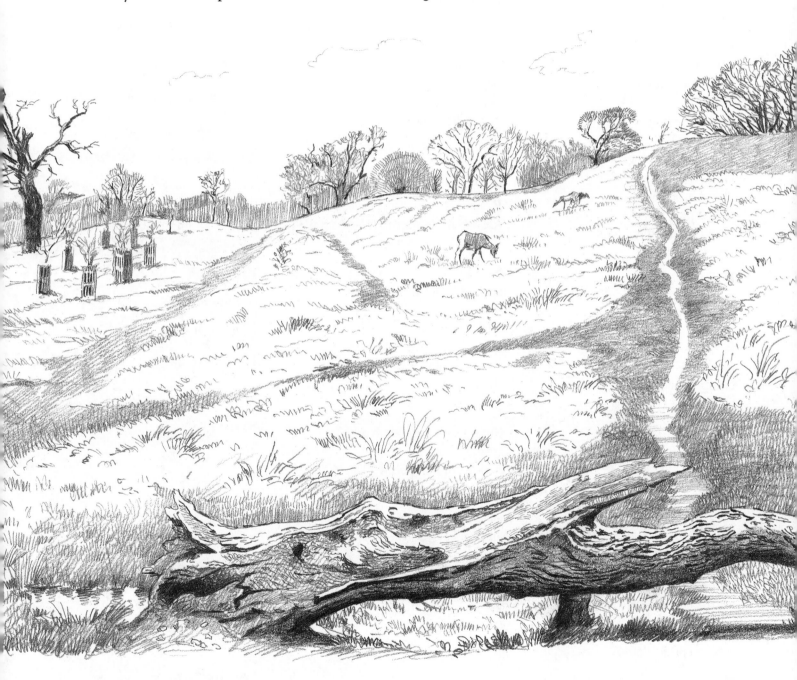

Index

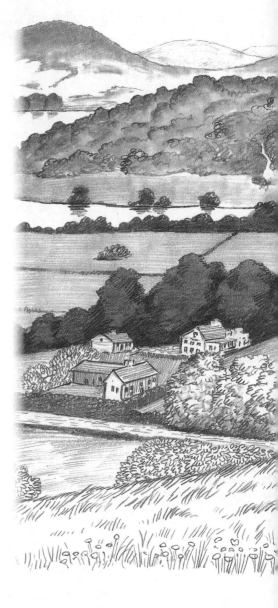

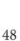